PUBLIC LOVE

PUBLIC LOVE

by Talmage Cooley and Andy Spade

CHRONICLE BOOKS

SAN FRANCISCO

Library of Congress Cataloging-in-Publication Data:
Public love / edited by Talmage Cooley and Andy Spade.
p. cm.
ISBN 0-8118-2153-6 (hc.)
1. Sex—United States. 2. Public spaces—United States.
I. Cooley, Talmage. II. Spade, Andy.
HQ18.U5P83 1999
306.7'0973—dc21 98-42891
 CIP

Design by Brian Lee Hughes

Printed in Hong Kong.

Distributed in Canada by Raincoast Books
8680 Cambie Street
Vancouver, British Columbia V6P 6M9

10 9 8 7 6 5 4 3 2 1

Chronicle Books
85 Second Street
San Francisco, California 94105

www.chroniclebooks.com

Things happen. Sometimes we can't know when emotion will sneak up on us, tap us on the shoulder, and wrestle us to the floor of an elevator.

This book is about those times when love didn't have the patience to make it to the bedroom. Those times when it overwhelmed our better judgement and plopped itself down wherever it felt comfortable.

This book teaches us that love is an unpredictable, insatiable, demanding force that makes its will known in the most inconvenient times and places. The stories within are not meant to be shocking or exploitive, but honest and intriguing. Each came straight from the individual who experienced the act of public love and is offered in his or her own words.

We thank the brave men and women who agreed to be interviewed for this book and would like to list their names in gratitude. But we refrain because if we did they would never speak to us again. Thank you. You know who you are.

Talmage Cooley and Andy Spade

I DATED THIS WOMAN

who always wanted to put me in a position where I was vulnerable. I guess you could say she had a power

issue. She also had a particular talent for giving oral sex. It was her mouth, it was her hands, it was the noises she would make. She had an aptitude. She would attack me in cabs, restaurant bathrooms, elevators. But her most brazen act was at about 1:30 in the morning when we were walking across 55th Street to my apartment. The street was fairly clear because it was late, and there weren't many people walking around. She stopped me in the middle of the street, pulled my zipper down, and started to apply herself. I was standing there not knowing what to think, but also being quite amazed that I was in the middle of this act in the middle of 55th Street in the middle of New York City. There was a certain intoxication to it. I could see down 55th Street, I could see the cars beginning to line up on the other side of Broadway at the red light. I knew we didn't have much time and I said to her, "The cars are coming." She didn't stop. In fact, her grip on me actually tightened. I was completely overwhelmed by what she was doing, but I was also aware of what was about to happen. Down the street I could see the "Don't Walk" sign change to "Walk," and I knew that the light on the other side had turned to green. When the light goes green in New York it's like a drag race starting. I could see the cars lunging towards us. She was watching them, too. I said, "I think it's time to go," but she still wouldn't stop. The cars were rushing towards us and one of them was blinking its high beams at us. When they were probably no more than thirty feet away she finally stood up next to me, kissed me hard on the lips, and pulled me to the side of the street just as the cars flew by with their horns blasting. **HENRY**

I HAD AN INCREDIBLY FLIRTATIOUS

relationship with this guy in Seattle. It was a really weird relationship because it was never truly consum-

mated. I was married to someone else, and it was just too complicated. But I was fascinated by him

because I had heard that he was into S&M, that he had slaves and everything. I was very curious about

it. So we ended up having this very intense friendship with heavy sexual overtones and we would have very explicit late-night phone calls. At some point I was in L.A. for business and staying at a very nice hotel, and he came down to visit me. I was definitely curious about the S&M thing and so I had to push it, I had to find out. He met me and we went out to dinner. We got into a very intense sexual power dynamic that night, and it was very hard to say who was in control and who was not. I took him back to my suite and we were really worked up from dinner. I guess the tension had been building up between us for a while. Pretty soon he had me over a Queen Anne chair, naked, and he was spanking me. At the same time he was masturbating. It was a Sunday, and right outside my bedroom was an indoor courtyard where the hotel held fancy affairs, weddings and stuff. Suddenly I realized that the sliding glass door to the courtyard was wide open and I was hearing an orthodox Jewish wedding being performed outside. A cantor was singing, the whole thing. And then I realized that the loud smack of his hand across my ass was echoing through the courtyard. I became intensely self-conscious, knowing that the wedding party was hearing everything we were doing. I didn't want to make a lot of noise, but every time he smacked me I couldn't help but let out a gasp or a moan. In between smacks I kept imagining the faces of the wedding guests. The smacks kept coming. He kept masturbating. I'm bent over this chair, staring at the carpet and moaning. Outside you could hear the sound of glass breaking and the shouts of "Mazeltov!" Finally he came and fell on top of me. People broke out in applause. It was so weird. **JUDY**

I WAS FIFTEEN YEARS OLD

on the beach on Block Island, the summer place where I've gone all my life. This was the first year that I had friends come out with me, and it was the first summer we didn't go to the beach with my parents. We went to this other beach where all the older kids would hang out and drink beer. It was the party beach. So I'm lying on the beach and this guy comes up to me and my friend and starts talking to us. Within ten minutes he says he wants to show me something. So I go with him to his royal blue Volkswagen van in the parking lot, and there are two friends in the van. I could tell they had just finished having sex. I'm introduced to these two people and then they leave. He and I go into this van. It was the camper style of VW bus, and it had a bed. Basically he takes me into the van and we start fooling around. I had only known this guy ten minutes. Also, I told him I was sixteen because sixteen sounded much older than fifteen. I really felt like that made such a big difference. So we start having sex. My God, I'm having sex with a total stranger. There are people outside the van, these people who had been in previously. They are peeping in through the window. We both see them looking in, but we just keep doing it. And then they start rocking the van. I had no idea how many people were outside the van now. He says to me, "You seem a little tense." I said, "Well, I don't even know your name." "They call me Surfer Dave." That's what he said, "They call me Surfer Dave." All I could manage was, "OK." It all seems kind of cheesy now, but you know, that was the first orgasm I ever had, with Surfer Dave in the back of his van. He was twenty-four. I was fifteen. Oh yeah, one more thing. Surfer Dave didn't surf—he didn't even have a surfboard. **APRIL**

I USED TO MEET HER FOR LUNCH

sometimes at this old elegant hotel downtown. I had fallen in love with her the first minute we met, but nothing could happen because she had a boyfriend. The thing I remember most is that it always astonished me how much I loved just looking at her. So we were having lunch one day at this hotel and she started talking about how she was kind of conservative and she wasn't very experienced with men, but she wanted to be. The conversation kept getting more specific and our lunch turned into an afternoon. At some point we ended up together in front of the bathrooms, and the next thing I knew she was leading

me into the men's room. It was an amazing bathroom really, very old and grand and cavernous. We ran into one of the stalls and started making out feverishly. Her legs were straddling the toilet and she was facing away from me and we started to make love. Suddenly there were footsteps on the tile floor and we both froze. I was inside her and we were both trying not to move a muscle. We could hear a man walk up to a toilet, pull his zipper down, and do his business. It seemed like any sound at all was amplified a million times in there. He finished and pulled his zipper up. We could hear every detail so clearly. He washed his hands and finally left. She was more nervous now. We started again and just as we got going another set of footsteps came in. Right behind that came a second set of footsteps. It was the same thing as before, but now we had two men at slightly different intervals going about the identical bit of business. It's amazing what a ritual it is, the sameness of the actions, the sameness of the sounds. She was getting really nervous now. As the two men were both washing their hands, I started to move inside her again, and she started to wave her hand, wait, wait, wait. But I couldn't wait. As I pushed I tried not to make any noise in any way. She was doing the same thing, to the point that she was even trying to hold her breath. It required total concentration. When the men walked out she turned around and she was shaking. She pulled up her underwear and we went back to the safety of the bar. After a minute she started smiling and I could tell that she was no longer nervous. She always says that was a big milestone for her.

KENNETH

I USED TO TAKE GREYHOUND BUSES

home from college on Thanksgiving and on Christmas. There's something about the vibration, and this feeling of going from one place to another, and this empty span of time where nothing's happening. It's three hours from Boston to Connecticut. You know, I could make myself come just from the vibration of the bus. A good thing is to get on the hump between the two seats, because then you have a little pressure as well to go along with the vibration. Also, if there was someone next to me, I would work myself up into such a state where I was like, this person must know how I feel, and if they do something at this moment I would be completely open to it, whoever they are. But no one ever did because I don't think anyone would ever expect that you would like a total stranger to start fooling around with you on a Greyhound bus. **RITA**

THE BASEBALL FIELD AT MY SCHOOL

was one of those ones that has four diamonds all adjacent to each other. A game was being played one night on the field next to the empty one where I was trying to put my hand up Jodie Patterson's shirt. I was being cheered on by about fifty or so parents (my mother included, because my brother was playing in the game). Feeling up Jodie was pointless, but I was enjoying it anyway, when suddenly the crowd went wild. I mean, they were going crazy. Then we heard a ball land. We looked over and twenty or so feet from us a ball was rolling in our direction. Someone had hit a home run into our field. A few seconds later we saw one of the players coming to pick up the ball. We didn't make a sound, and the kid getting the ball didn't notice us in the dark, but it made Jodie so nervous that we left the field. Whoever hit that home run was no hero of mine. **ANDY**

I WENT WITH A FRIEND TO JAMAICA.

It was an innocent invitation I made to her on a cold winter's day in New York. Well, maybe it wasn't so innocent, since I had fallen in love with her, but she wasn't in love with me. It sounds cheesy, but I was desperate. Anyway, it worked. She went with me to Jamaica and we fell totally in love. Maybe desperation is the mother of invention. After our week of bliss we were on our way back to the airport and we got drunk

at some shack along the road, that languid kind of island drunk, and we missed our plane. There were no guards at the gate and we ran out onto the runway, laughing and chasing this big 767, but it didn't stop and we had to walk back to the airport and catch the next one. We got into Newark Airport late, and took the bus to the Port Authority terminal in New York. When we got on the bus we noticed that everyone on it—there were about six of them—was seated right behind the driver. It was very dark. We walked all the way to the back and sat on the big bench seat there. The bus went round and round the airport and then pulled out onto the highway. We were going down the New Jersey Turnpike at a fairly decent clip. There was a very long distance between the people in the front of the bus and us, kind of a dark gulf. She pulled up her skirt, took her underwear off, and I pushed my pants completely off. I think I was still wearing bermudas. She sat on my lap facing forward, leaning onto the seat in front of her, and I reached my arms around to touch her as I went inside her. When we came up to the toll booth the bus slowed and the noises of the road rushing by suddenly died. The bus became intensely quiet. She was a sexually vocal woman, and I could tell she was trying hard not to make any noise. I kept going, and it was obvious she was really losing control because her whole body was shaking and her breathing was getting crazy. Finally, the driver paid the toll and the engine roared as we pulled away. The noise wasn't enough to hide what was going on, though, because right after she came, the driver turned the lights on and watched us in the mirror the rest of the way. **CLAYTON**

WHEN I WAS IN ART SCHOOL

he used to drive me to school early in the morning. One time we were parked across the street from the school and we were having a hard time separating. We were sitting in the car in plain daylight and we started kissing. We didn't have sex, but basically what happened was that he made me have three orgasms in the car without removing any of my clothes. He was just using his hand. When I first met him I didn't like his hands. I thought that they were unattractive, because they were really thick and his fingers weren't very long. But now I think they're really beautiful. Anyway, he just had his hand between my legs. Since I was a teenager no one's really tried to do that to me. I had these pants on that were really big because they were my painting pants, and I got very messy painting at school. He put those hands on me through those pants and I had three orgasms in a row. He was so amazed, so pleased that he was making me happy.

TEMPEST PART 1

AFTER THE THING IN THE CAR

I said, "Why don't you come inside the school and sit for me and I'll work on your portrait?" I had a

beautiful studio on the attic floor of the school, a private studio where the sunlight would stream in. It was very white and very beautiful. The only glitch about the studio was that in the mornings there was a class going on in the room adjacent to it and there was only a sheet hanging as a partition between the two rooms. The class next door was taught by this 90-year-old woman who's slept with everyone from de Kooning to Pollock. When she was next door you could hear her voice, this very creaky old voice, complaining about somebody's work or yelling at them. So, my boyfriend came up and sat down to pose. We looked at each other, and it was like we had never left the car. I was still riding a wave and I hadn't come down yet. Basically I wanted to have sex again and I didn't care about where we were. We started kissing and this time he took all of my clothes off, but he didn't take anything off. This was only four feet away from the sheet partition that separated us from the classroom of people. It was funny because in the room next door there was a nude model and she was being painted, and here I was in my own studio, nude, and I guess we were thinking that if anybody walked in we could claim that he was painting me or something like that. But that would have been kind of a stretch since he was not a student at the school and he wasn't even a painter. We had sex right there on the floor and the whole time I could hear people talking. At any point anyone could have walked in. But it was just one of those things where you're focused on one thing and everything else becomes hazy. For weeks after that happened I could hardly stand in my studio. It was unnerving. He was all I thought about. **TEMPEST PART 2**

SHE AND I HAD BEEN FLIRTING

for weeks and finally we got drunk enough to have the courage to take it further. We were stumbling around the East Village, on 5th or 6th Street or something, and we stopped at Avenue A to get a cab. Either she grabbed me or I grabbed her, I can't remember which, but we started kissing and groping each other there on the street. A cab stopped, but we waved it on so we could continue what we were doing. Looking for a hideaway, we found a building entrance. We went down the steps and pushed open the door. You know that area between the two doors where the mailboxes are? Well, we stopped there under the bright lights and she started undoing my pants. Next thing I knew she was on her knees making me happy. Then the door flew open. A beautiful girl in her thirties walked in and made her way past, completely unfazed. As I'm trying to mumble an apology she says, "Don't worry about it, I've been there myself a few times." Then she disappeared up the stairs. God, I love New York. **LLOYD**

I WAS LIVING ON AN ISLAND

in Maine for the summer. On the Fourth of July a group of us went to the village green to watch the fireworks. I was with my boyfriend for the summer—this tragically beautiful nineteen-year-old boy who was very tall with long blond hair and blue eyes. He was absolutely delightful and exactly what I needed that summer. After the fireworks we decided that it would be a good idea to go out on the water to see the phosphorus. So we went out on a friend's motorboat into the middle of the harbor. If you stuck your head over the side of the boat you could watch the wake stirring up the phosphorus. Everyone was trying to scoop up handfuls of glowing water. All my friends were in the front of the boat and the skipper was driving. My boyfriend and I were sitting alone on the stern. He had this blue Macintosh on, I have no idea why, but he did. With the skipper not three feet in front of us, we started to make love. I just sat on top of him, pulled the blue Macintosh apart, and moved up and down. Everything was so exactly in tune, and the sea and the boat seemed to be doing all the work for us. It was perfect and no one seemed to notice. At least that's what I thought until I realized the skipper was working the throttle so that the boat would keep hitting the waves in perfect rhythm. He kept that up all the way back to the dock. That was a great summer. **JANE**

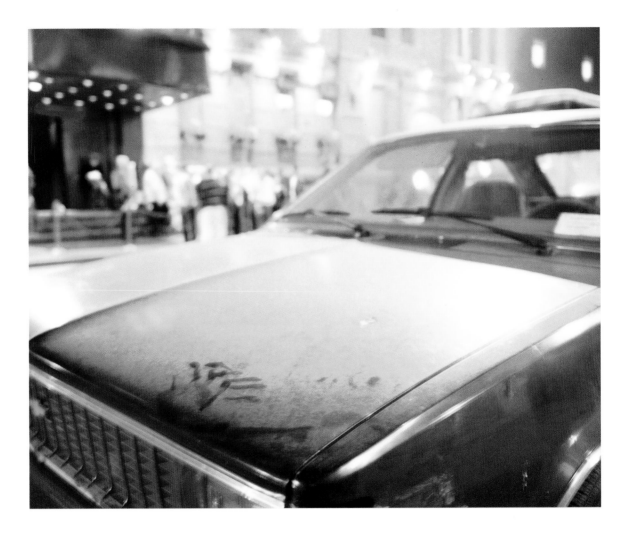

I HAD BEEN CHASING HER FOR A LONG TIME.

Finally it was my time. We did not know each other very well at first, but things progressed in a very natural way. We would go out and have fun, go to the beach and be silly, it didn't really matter because we were falling in love. So one night we were in a club and we had this strong desire to make love. We came out of the club and I put her on the front of this car and we started to hug each other. I pulled up her skirt. She had on this very short skirt with no underwear. I started to hug her and make out and then I unbuttoned my pants and we started to make love. The intensity was increased by people going to the club and passing back and forth right in front of us. But they probably didn't notice anything because her legs were wrapped around my waist. The desire to be inside of her was so strong, but I had to be careful because if she let go of me with her legs my pants would fall down. **EDUARD**

I WAS OUT WEST

learning how to rock climb at this resort. My climbing instructor had been flirting endlessly with me, and one day he was going to give me a free lesson. When I went to find him at his house, it turned out that he had prepared this whole picnic for us. We hiked up this mountain, and we ended up at this amazing waterfall. It was magical. We found a little clearing where the sun was shining through. Even though it was spring, it was still pretty cold up there. He had brought some blankets and we laid it all out and had our picnic. The day wore on a little bit, and the sun was warm where it hit us, so we opened up our shirts to get a tan. He started opening his up a little bit more, and then I opened mine up a little bit more. Soon I had my shirt open all the way and we're madly making out. Then he took off my pants and he started doing me, with the freezing ground underneath me and the sun making me sweat on top. And it went on forever, just forever. Meanwhile, even though it was pretty far out of the way, there were still people hiking around the waterfall, and it was crazy because we were rolling around on the ground having mad sex, very raw and dirty. Then we heard people coming. I was thinking, "Oh my God, hurry up." But he kept going. We could hear their voices and I could see the tops of their heads but he kept pumping away and we were just going for it. And then we both came, screaming. We made a mad dash for our pants, but the people saw us anyway. What can I say—I still go to bed thinking about it today. This guy was a bone and a half.

PATTI

I WAS DATING TWO GUYS NAMED JOHN.

One was in New York and one was in Los Angeles. So geographically it didn't seem like much of a problem. So I went to L.A. to visit one John. He was very Hollywood and I was at an age where I could buy into that whole scenario. His family had a huge mansion in Beverly Hills, and that's where I stayed. His parents were very open and liberal about their kids having sex. "Sleep in the same bed as John, do whatever you want. We don't care. We are very open about these things." I remember our bedroom was right next to his parents' bedroom. No matter what they had said I still felt kind of uncomfortable about having them so close while we were having sex. So we ended up doing it in other places besides the bedroom. One night we went outside. They had this massive pool with fake rock formations and white marble statues of angels with water spouting out of their heads. It was very Hollywood. Very gaudy. We went back by the fake rock mountain and we had sex against the rocks. The sex lasted for a couple hours and I really banged up against the rocks. I was enjoying the sex so much that I really didn't notice what all this banging was doing to my back. Afterwards I said, "Damn, my back is hurting me." He said, "Turn around." When I did he was shocked. The skin was scraped off of my back almost to the bone. I was in horrible pain and I had to see a doctor the next morning. I told the doctor that I had slipped on a rug, but I don't think he bought it. When I got back to New York, my New York John wanted to know how I got that nasty wound on my back. I told him I had slipped on a rug. He completely bought it. I still have the scar.

EMILY

I WAS NINETEEN

and my boyfriend came up for my first sorority formal, where I was to be sworn in as a Chi Omega pledge. Of course I had to wear the long white dress. During the formal dinner I took his hand and slid it up my dress and put it on my growler. That's what we call it in my family, your growler. I wanted him to know that I didn't have any panties on. So while this 900-year-old woman gave this speech about what it meant to pledge Chi Omega and sing the special candlelight song, he sat there and fingered me. It was so fabulous. The old lady rattled on about Chi Omega and other girls at the table were getting teary-eyed. I was sitting there trying to look like I was paying attention and meanwhile he was just totally getting me off. When I have sex I get flushed and I start getting red right in the middle of my chest. So I'm just getting redder and redder and redder and some girl next to me goes, "Honey, are you allergic to dinner?" I just said, "No, I think it's just a little warm in here." Meanwhile, he's still got his hands in my crotch. After she finished her speech, I got up and went to the ladies' room. When I came out he was waiting for me with this smirk on his face. He pulled me up these stairs, hiked up my dress, and railroaded me against the wall. I had my legs up in the air and we did it right there. Then we went back out on the dance floor like nothing happened and just danced for the rest of the evening. It was so great because nobody knew what we were doing at all. I remember that all the speeches were about being good to your sisters and being moral and pure. And there I am, doing the thing that's the least pure. In their eyes, at least. **VALERIE**

I MET THIS GIRL IN THE LIBRARY

at my college when I was eighteen. We started talking, and we got into the subject of sex. And I said,

"You know what, I've never had sex." Honestly, I was eighteen years old and had never had sex. She said,

"Wow, what a coincidence, me too." She was this foxy Italian girl. Her father owned the ravioli store two

towns over from me. We started studying together, and one day we got in her dad's big car and drove to this marina and started kissing. All of a sudden she pulls her pants down, pulls her underwear down, and puts her ass up right in my face. She says, "Put it in." I looked at her ass and I freaked out. All I could say was, "Put it in?" Meanwhile, I've never fucked in my life and to top it off, I looked down at my dick and it was as scared as I was. I said, "Are you sure this is how you want to remember the first time?" And she said, "First time? what are you talking about?" I said, "This, our first time." She was like, "What the fuck are you talking about?" I said, "I've never had sex before." She said, "You mean you weren't kidding when you said that?" And right then and there my dick disappeared completely. I felt like the biggest asshole. Here I was, a virgin, and I was sitting here with the hottest girl, who's turned around with her ass in the air asking me to put it in, and I'm completely limp. So to make matters worse she got down and started sucking my dick. I just got smaller by the second. I thought, I've got to get hard. I thought to myself, send messages to the dick, get hard, get hard. No luck at all. I zipped up my pants. She pulled her pants up and put her bra on. It was a fifteen-minute ride home at most, but it felt like forever. The story has a good ending, though, because taking my virginity became her mission. About a month later we were in the same car in the same place and to this day, ten years later, I've never been fucked like I was that second time with her. She was unbelievable. I mean, there have been girls who have been crazy and exotic and this and that, but I think that because it was the first time I ever had sex, it was the best. **CHAD**

ONCE WHEN I WAS HOME FOR THE SUMMER

I hooked up with this guy who became my boy toy. He was so good-looking and a total pothead. You couldn't talk to him that much but he was complete yum. At the time my mom wouldn't let me have sex in the house or have somebody stay over. So whenever he would drop me off after we went out, we would have mad sex in the driveway, which happened to be right outside my mom's room. I'm telling you, it wasn't quiet sex. It was sort of like me saying to my mom, all right, you won't let me have sex in the house, so I'm going to have it right outside in the driveway. We did this all summer. And there was this woman who lived right next door and there were just a couple of bushes separating our house from hers. One time I looked over there, and she was sitting in a chair just watching us have sex. I think that she was watching us all summer. One night after we had had sex in the driveway, my boyfriend backed out of the driveway and immediately got pulled over by a cop right in front of our house. I walked towards the car just as the cop made him get out and show his driver's license. So all three of us were standing there and at the same moment we all notice that there's a wet condom stuck right on top of my boyfriend's shoe. The cop stared at us both and then went to his car and talked on the radio for a while. Eventually, the cop let us go, but to this day I still wonder who called him to the house. **NIKI**

A FRIEND OF MINE

owned a fashion boutique just off the main thoroughfare, and I used to go in and help her out occasionally. At the time, there was this publication called *Fred,* a very small magazine with art, photographs, some stories, and a lot of fantastic pornography. So, I was behind the counter this one day, and I started reading this really erotic story. It was quiet in the shop, so I picked a moment when no one was coming in, and I stood there and wanked off under my dress. I was leaning against the counter while people strolled by outside the shop window. It's a trick I mastered in boarding school, how to do the deed without anybody knowing what you're up to. Quite handy. **ABBY**

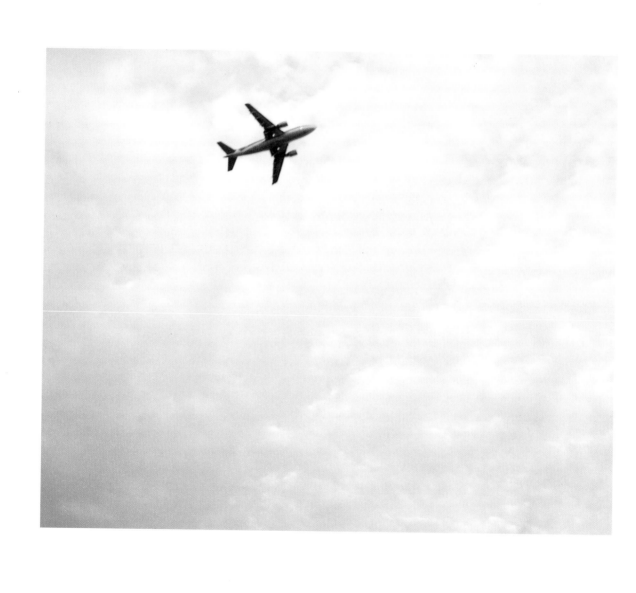

MY FAMILY, MY COUSINS, AND I

used to travel back and forth from our house in Canada to my grandmother's place in Florida. I was just eleven, but we were getting to an age where the older kids were growing up and starting to rebel. My oldest cousin was this very handsome fifteen-year-old boy who was always getting into trouble. But I never really understood what exactly he was in trouble for. So, we were on this plane going to Florida, and I was sitting next to him, and he kept looking up the aisle at something. After a while, he wrote something on a piece of paper and folded it up and asked me to take it to a girl sitting a few rows ahead. Maybe I was naive, maybe I still am, but I had no idea what he was up to. He made me promise not to look at the note. I went up and gave it to the girl, and a few minutes later my cousin left his seat and the girl followed him back to the bathroom. I couldn't understand why on earth two people would want to go into the bathroom together. Eventually my cousin came back, and he was all smug and had this grin on his face. It was my first exposure to sex, even though I hadn't actually seen anything going on and I hadn't done anything myself. Somehow when he came back and sat down, it was like a lightbulb turned on in my head. From then on I started being aware of all the sex that was going on around me. That was the beginning for me. **BROOKE**

I ALWAYS TOOK THE TRAIN

from Washington to New Orleans because it was such a beautiful ride and I would always meet these weird

and interesting people. Even though I always got a sleeper I never hooked up with anybody. But one time

I didn't get the sleeper. For some reason my ticket got screwed up and there was just one empty coach seat available. I sat down all pissed off because I had to sit in one position for twenty-five straight hours. I sat down and got settled, looked over and there was this really good-looking guy. I thought, all right, maybe it's not so bad after all. We started talking, and then we ended up going to dinner together. He was nice and had one of those waspy New England accents. I can't even remember what he looked like. I just remember that I liked talking to him because he had such a beautiful mouth. Everybody seemed to think that we were newlyweds, so we started going along with it. We made up this whole history about ourselves. It was incredibly elaborate and we thought we were so clever and charming. After dinner we went back to our seats and eventually started making out. When they finally turned out lights he started taking my clothes off. People weren't even asleep yet, but when it seemed like they were asleep we started having pretty raucous sex in the seat. There was this guy across from me who was snoring really loudly, and I was trying to time my moans to his snores. After a while he woke up, I think, because the snoring stopped. In the morning we went to breakfast and people were kind of looking at us funny. I didn't care because everyone thought we were newlyweds and he was so sweet. At the end of the trip he gave me his address and I wrote to him a week later, but the letter got returned stamped with a notice saying that no one by that name lived at that address. It was okay though, because it was like I made him up, like the whole thing was a perfect story I had told myself over the course of twenty-five hours on the train. **JEWEL**

THIS IS ABOUT A GUY

I was seeing where our relationship sort of started in a cab. A bunch of us went out for dinner, and then we decided to go to a club. There were too many of us for one cab, so he and I were pushed away from the group and told to go in our own cab. We had kissed before, but for some reason, maybe the wine, I decided that I would give him a blow job in the cab. It was a Friday night, traffic everywhere. It was really exciting. I thought, "I'm going to do it." The thing is, there's no partition in the cab between us and the driver. I bent over anyway. Our friends were in the cab behind us, and I knew they were watching. I quickly became wrapped up in the moment though, and I just started going for it. So I'm giving this guy a blow job. I can see lights passing by me and I have no idea where I am or how much time I have. It became a challenge. I love giving blow jobs, so that's no problem. But I realize, giving this blow job, that I've got to make him come before we get there. I know he's thinking the same thing. It would be sort of an unsuccessful mission if it didn't happen. The cab ride was only about ten minutes long, but it seemed like time was totally suspended, like every second was precious. And it was. There would be moments when I thought, he's going to come, he's going to do it. And then it wouldn't happen. Eventually I thought, "OK, this is it. Try every technique, every trick you've ever learned." I tried to recall any little thing any girlfriend had ever told me. Girls share these stories all the time. Then I tried to think of new techniques, to really improvise. In a way I felt really alone, down low in the cab with him up there. Then we turned a corner, and just as the cab stopped, he came. Victory. **AMANDA**

I USED TO DATE THIS GUY

who worked for a magazine, and it was one of those purely sexual relationships. I thought he was kind of cute in the beginning, but he was a very angry person. He had this thing about always wanting to make love in the elevator in my building. We'd always go to the Odeon on Friday nights, and we'd sit there and order mashed potatoes and spinach and red wine. Then after dinner we'd go to my apartment and get into the elevator. As soon as I pushed the button he would be all over me. He was very brutal, I mean, I was always like, "Oh no, you can't do this," or, "Someone's going to find us." But he would just insist on

doing it and wouldn't take no for an answer. He would take my clothes off in the elevator and just do it to me. I only lived on the fourth floor, it wasn't like we had to go up to the twenty-second floor or something. He would turn the lights off in the elevator, but he would never push the stop button. It was always kind of late at night, and when we got to the fourth floor we'd just stay at the fourth floor and make love in the elevator right there. I was always afraid that someone would try to get into the elevator, that someone would press the button and we'd be there and I would be all exposed in front of this person. The elevator had this horrible light in it. It was a typical bad elevator. Kind of dirty, kind of skeevy. And I remember that while we were making love, or fucking, whatever you want to call it, I'd always be looking at that little sign showing the inspection ticket. You know, the guy who inspected the elevator, his name. And I remember the guy's name was J. Crespo, and he had inspected the elevator every year for the last five years. J. Crespo 1992. J. Crespo 1993. J. Crespo 1994. Anyway, this guy I was with was kind of smelly. Kind of scary. He wasn't a happy person. I think at the time I wasn't looking for a lovey relationship, I was just look-ing to have sex with someone. And that's what he was to me. Still, he needed me in some way, and when it broke up I upset him more than I thought I would. I didn't think it was going to affect him in any way.

RUBY

ABOUT THREE YEARS AGO

my boyfriend had a very serious heroin habit that he was trying to kick, and one of the first things that

happened was that he replaced heroin with sex. I'd spent the last year not getting enough sex, so it seemed

like a real explosion of love. At the same time it was a little scary because I had this vague feeling that his

obsessiveness was somehow unhealthy. Anyway, he had this old car that he loved. It had a hole on the

passenger-side floor so you couldn't put your feet down, and the gear shift would come out while he was driving. The thing was a wreck, but he was really into that car. We used to spend a lot of time in the car since we couldn't really go back to my apartment because my roommates didn't want him there. They were really paranoid about him stealing. Nobody trusted him except for me. One day we were driving around looking for a parking space. It was kind of cold and rainy. When we finally found a space, we started kissing in the car and it got intense fast. I climbed over to the driver's side and we had sex—straightforward sex, intercourse. There was no room to maneuver and my back kept hitting the steering wheel, but I loved it. It was amazing, because after a couple of years of him having very little interest in sex, now he could have sex like a nice 18-year-old. I had no problem with that. I remember people walking by and seeing their shapes through the fogged-up windows. I couldn't tell if they could see what we were doing. Then somebody tapped on the window. Even though he was still inside me, my boyfriend rolled down the window a couple inches. A policeman had his face right against the window and he was checking out the whole scene in the car. The windows were totally foggy, so the cop could see through just the few inches that the window was rolled down. I had my shirt on but my jeans were off. My boyfriend had his pants around his ankles. All the cop said was, "I think you'd better find another parking space." My boyfriend rolled up the window and the cop didn't stick around. We finished because there was no way I was going to let him stop at that point. It was very sweet. **NICOLA**

THE THING ABOUT HIM WAS

that he just loved to have sex. He could have gone twenty-four hours a day. Around the clock. For a while when the passion was good it was great. One time, his mom had rented this beach house, and we were out on the beach about two o'clock in the afternoon in the middle of summer on a blazing hot day. We were surrounded by crowds of people. He was lying on a lawn chair and he told me to come over. So I got on the lawn chair with him and we started fooling around. We ended up having sex on the lawn chair in the middle of the day right there with the people. We tried to put a towel over ourselves, but my bathing suit was completely down and everyone obviously knew what we were doing. It didn't even seem like it was me doing it, it was more like my evil twin. I'd never done anything like that before. This guy was a real take-control guy. Guys like him make it seem like everything is fine. Because then for me if you tell me it's fine, it's fine, you know? I don't know, maybe it has something to do with church. **MARY**

IT WAS THE SUMMER, ABOUT SIX YEARS AGO,

and I was with the guy who is now my husband. This was during the time in our relationship when we used to have sex all the time. Five or six times a day. That was kind of where we were in the relationship. One day we stopped at some cheap lingerie place and bought a pair of crotchless panties which turned us on so much beyond exciting. We were driving along the road home when the urge overcame us. We had to make love right then and there. There was no question about it. We couldn't wait to get home, we couldn't wait to get a motel, we just had to do it right then. So there was a billboard on the side of the road, on Route 27, I guess. The billboard was like, Fred's Lobster Shop, Fred's Lobster Haven, or something like that. We drove behind this billboard right beside the highway and parked the car in some bushes and went underneath the billboard and made love. We were on the ground. Cars were going by ten feet away and we were kind of afraid someone would find us. But it was no big deal. We had to do it. **DREW**

L: I REALLY DIDN'T KNOW HIM VERY WELL,

but I was really attracted to him because he was a very big guy. **C:** And we were kind of in a wild mood that night. **L:** Yeah. Things started to sort of heat up in the bar. And then we started getting a bit toasted and we would go to the bathroom together and talk about how cute he was. **C:** We'd talk about which one was going to go home and fuck him. We were very generous about it. No, you can, no, you can. **L:** Of course, neither of us was really supposed to be doing anything like that. But that's another story. **C:** He was really attentive to both of us and listened to everything that we had to say, holding on to every word. We were like, this guy's a gem. **L:** Did you kiss him first? **C:** No, it was weird. I got up to go to the bathroom and then you got up to go to the bathroom and then you leaned over and all of a sudden out of nowhere you just start kissing him. **L:** What happened next? **C:** What happened next was you said,

"He tastes really good, why don't you try?" At that point I kissed him and then you started kissing him again. Then we look at each other and we start kissing. **L:** I have to say it was really nice. **C:** It was awesome. And then it escalated. **L:** I think we all made out while we were standing up by the bar. **C:** It was like we were all sharing. **L:** He had very nice lips. Very full. That was one of his selling points from the beginning, his beautiful lips. **C:** And then we start getting up on the bar. People started making comments and watching us. **L:** At that point we were kind of drunk and we were like, who the fuck cares about anybody else. **C:** Right, because we were fully onto our own thing. **L:** Right. **C:** We went outside and it wasn't clear who was going home with whom. We got in a taxi and... **L:** Well, I think you were touching me but I don't remember that as well as me touching you. I remember that. **C:** Well, at this point I was like, he can go home. We don't need him anymore. **L:** At first we needed him to be involved. We were in team exhibition mode and we were going to drive some guy insane. It was kind of like a little game we were playing. But then we were like, Hey, this is not bad. At which point I think it got a little scary also. I was like, This is my best friend, I don't want to do anything wrong but... **C:** Yeah. And then I realized that he wanted to come home and like, I didn't want him anymore. So I went home alone and you went home with him. **L:** I went home with him and that's not very interesting. Pretty straight-ahead predictable stuff. He still calls me though. He called me last night, as a matter of fact, at three in the morning, muttering. **C:** Did he really call you at three in the morning? **L:** He still wants us both. **LILLY & CAROL**

I ONLY GO OUT WITH ITALIANS.

This one Italian guy was named Frank. He was very well endowed and he had the most beautiful body in the world. He had a really hairy chest, which is so hot. Though I guess that depends on the chest and the hair. Anyway, this guy was sick good-looking and he was a surfer. Italians surf too, you know. I fell in love with him immediately. We started having all these crazy times and one night we were out running around like mad people and decided to go down by the river. It was five in the morning or something. Next to the park entrance there was a security guard's van with two security guards inside sleeping. There was a really high fence around the park, eight feet or something, but we knew the guards were sleeping, so we just climbed over. We sat on this bench and it was great because I had a little skirt on that made it so easy. He pulled my underwear off and I sat on his lap. I love that. Then we hung out a little. The sun was starting to come up behind the buildings, so we went into some shade on the grass. We got totally naked then, and I think he was on top. He was so much the hot body and I'm so about the hot body. With him it was very hard not to be about that. He never really was in love with me. But it didn't matter because I just love Italian guys. I think it's a really sexy culture and it's OK to be sexy there. Plus, the food is amazing. I've never been to Italy but I fucking love that country. **TINA**

SHE STARTED SENDING ME MESSAGES

on the computer at work. She was just getting out of a relationship and so I was perfectly willing to take it

nice and slow. But it didn't work out that way. We went out once for coffee and ended up sleeping together.

The next day at work all these messages kept popping up on my computer and they were pretty obscene. I was getting kind of embarrassed. I said to her, "Why don't you meet me in the parking garage and we can talk." I just didn't want anybody in the office to find out, because you know how office gossip works. It turned out that she was even better at keeping things quiet than I was. I found out later she was dating somebody else in the office at the same time, and I didn't know it. He was actually a pretty good friend of mine and they were keeping it real quiet because he was married and getting a divorce. So she met me in the parking garage, and we started talking. I said, "You know, that was fun last night." She said, "Yeah." There was no stopping it. It kind of had a life of its own. Before I knew it, we were having sex against the wall. She was really very attractive, very fit, and always wore skirts and never any underwear. She was so little, you know, it was easy to move her around. It was summer and it was really hot, so we both walked out of the garage sweating like pigs. We ended up doing that every day for three months. It was insane. When I think back the best sex I ever had was with her. She's it. Maybe because it was kind of nasty. I always had big scratches in my neck and on my back. She had a different kind of understanding of the whole sex thing. At the end of it I got all depressed and then she ended up marrying the other guy at the office. I saw her about six months later and it was pretty funny because her husband kept an eye on me the whole time. I said, "So, you want to go to the parking garage?" She laughed and said, "You're so bad." It was worth a shot. **WILLIS**

MY SISTER AND I USED TO HAVE THIS GAME.

We would choose the guys we liked and see how long it took to get them. Most of the time we didn't sleep with any of them. One Christmas I went with my family to Aspen and we found these two ski instructors. They were really raunchy guys, but we liked them anyway. My sister decided she liked one, so I took the other. He and I decided to go for a walk outside the lodge in the snow. It was a bitterly cold night, I think it was the night after New Year's or something, and it was really quiet and there was nobody out. He took me over to the chairlift and we were talking a little bit. Then he suddenly lifted me up and put me on the chairlift that was hanging there and he just ripped off my pants. There was snow all around and snow on the chairlift, and I didn't even know his name. He just took off my pants and proceeded to start. I think the best part was that my ass was so cold, and then when he went down on me I just totally warmed up. I was like, I can do this. Then he came around from behind, and started to go for it with all of his might. He wasn't the best lover I've ever had, but he was pretty good. He obviously had some sort of goal, like how many girls he was going to fuck on the chairlift. I kind of figured that out after it all happened.

CHRISTINA

I DID NOT HAVE SEX WHEN I WAS IN HIGH SCHOOL.

But we had a lot of foreplay. We were all over each other anytime we could be. I can remember one night we went to this shopping center. It wasn't a mall, it was more like a wide-open building with no sides, lots of different levels and big glass elevators in the middle. It was nine o'clock at night, and all the shops were closed and nobody was there. We got in the glass elevator and pulled the stop button. It wasn't an alarm stop button, it just stopped the elevator. We ripped our clothes off and I remember feeling my bare ass pressed against the glass of the elevator. It was in the spring, just before graduation. I was pressed up against the glass with this guy going down on me and I just went nuts. Part of it was sex and part of it was being young and wanting so much just to feel as wild as we could. Later that spring I graduated and somehow that made it OK to start having real sex. But even after that started I always remembered how good I felt in that glass elevator. **CELIA**

AT THE END OF MY SENIOR YEAR IN HIGH SCHOOL

I met this beautiful girl. She was particularly attractive and particularly into sex. The problem was, we didn't

have anywhere to go except my parents' house or her parents' house, and that only worked when there

was no one else around, which wasn't very often. So I was always trying to figure out someplace else we

might go. One day we were walking around the park, and all I could think of was how to find an opportu-

nity to mess around. She was talking about this and that while I was just scheming. But no opportunity really presented itself, and eventually we started heading home. We went by this playground and started goofing around on the slides and climbing on the jungle gym. I got on this animal rocker thing and she straddled my lap. We started making out and then she said, "I have something to show you." And I said, "What?" She took her hand from around my back and showed me that she had her underwear in her hand. And so I said, "Hmm." She unzipped my pants and we started to have sex. It was cool because it was the first time that we were out of the house. She had a long skirt on, so people couldn't tell we were doing anything other than kissing. So we were doing it and I remember thinking, "Oh, man, this is great." And right then I looked over her shoulder and there was the biggest rat I had ever seen. He was just kind of poking around in the grass. I remember thinking that ordinarily I would be scared of a rat and I would try to get the hell out of there. But I was a high school guy with this hot girl doing this fun thing and I guess the urge of a young man to have sex was stronger than the urge of a young man to fear a rat. But the one thing I knew for sure was if she knew that the rat was right behind her, it would be all over. So I didn't say a word. There were actually some points in the whole thing where he got really close to us, just sniffing around, totally oblivious to us. It was really bizarre doing something so pleasurable and at the same time having to keep an eye on this grotesque rodent. Even after it was over I couldn't tell her because I knew that she would flip out and that would be the end of that. **GRANT**

SHE WAS THIS AWFUL LITTLE ACTRESS.

I can't even remember her name. But I have to tell you, she was one of the sexiest girls I've ever gone out with. I met her at this pool hall. As I was leaving the place she followed me out, came up to me in the parking lot and said, "Do you come here very often?" I knew I was in. We agreed to go to this hamburger place. About halfway through the hamburgers, she said to me, "Let's go and get naked." I was thinking, "This is starting out pretty good." So we drove in my truck to find someplace to be alone. We stopped at

a gas station and when I came back from paying she just attacked me against the side of my truck. People were going in and out of the gas station and she was going crazy. She's just the horniest girl I've ever met. We couldn't exactly finish there, so we got in the truck and started driving again. We found this campground and drove around all these windy roads looking for a spot. She was blowing me all the way. We pulled into a spot and climbed on top of the picnic table there. We were having the most amazing sex on that picnic table. It had a red and white checkered plastic tablecloth left over from somebody. Then we noticed that there was a family next to their little camper about ten feet away. There were two little girls, a little boy, and Mom and Dad sitting around this fire roasting marshmallows. It was the most wholesome American family you can ever imagine sitting there roasting marshmallows and singing songs. It was pitch-black out and the light from their fire didn't allow them to look over and see us in the darkness, even though we could see them plain as day. It was great. But it was also weird. Later that night she went a bit nuts on me. On the way home she kept asking me what my plans were, what was going to happen to us. She kept pushing and pushing. I said, "You know, do you want me to take you home? Because if you say one more word, I'm going to take you home." We were flying down the freeway and she said one more word. The way she said it I knew she didn't expect I was going to take her home. I peeled right off at the next exit and took her straight home. I parked in front of her house and she got out of the car and stood there, waiting for me to say something. I pulled the door shut and drove off. She was crazy. **NEIL**

I WAS IN THIS DIVE BAR

back in town visiting my high school friends. We were just hanging out and drinking beer, kind of catching up. I noticed these two girls sort of eyeing me from across the bar and I was eyeing them back. They eventually took off and I didn't really think much of it. My friends and I were sitting in the front of the bar by a window, and about ten minutes later I look and one of the girls is motioning me to come outside. So I go outside and we just started making out. Then all of a sudden I feel like I'm being sandwiched. Her friend is sandwiching me from behind and she's touching my balls and grabbing me. So I turned around and started making out with her, and I was basically switching from girl to girl out on the sidewalk. My high school friends are in the bar watching and high-fiving. You know, they're my totally goofy high school friends. The girls were saying, we've got a plan. So we walked around the block to the back of an abandoned warehouse. We just stood there and I tried to work these two girls at the same time. We all got pretty much naked but we didn't have sex or anything. Eventually I got off and so did they. They had this real attitude, like they were the guys in the situation. They were obviously out on a mission because afterwards I said, "Do you want my phone number or anything," and they just said no. I said bye and walked back to the bar. I didn't know their names. I didn't know anything. I went back to the bar and my friends were like, what the fuck was that. I just said, "It was fun." Those guys couldn't stop high-fiving all afternoon. **EDWIN**

HE AND I HAD BEEN TOGETHER FOR OVER A YEAR.

One night a bunch of us decided to go to this club that always had great music. We went, and there were a lot of people dancing. It was getting really hot, and we were sweating and everyone was taking layers off. He and I were dancing closely and I was like, fuck man, I really love this guy. I think, shit, he's so sexy and I've been with him for a year and how cool is it that I'm still totally turned on by him. So I get really close to him and say let's go to the bathroom. We go to the bathroom and close the door behind us. I bent down with my arms on the sink and he got behind me. I was looking in the mirror and we're totally having sex, fucking, the whole thing. Something was leaking. It was very dark, almost no light. I could feel the music pounding through the walls, and I kept looking at myself in the mirror and him behind me and thinking this is just so much. After it was done we put our clothes back on and went outside. There was this huge line of pissed off people. I didn't care about anything because I was in love. **PIA**

I GREW UP WITH THIS GUY.

It's weird when I think about it now, but I used to torture him about being so skinny and sweet and such a sissy. We really hated each other for a long time. All the other girls loved him, but I never felt that way. One day in tenth grade I woke up and I was a woman, and suddenly my teasing relationship with him turned into something else. I don't know how, but I think it was in typing class. He'd type me some little thing like, "i i i like like like you you you." We had this chemistry. We were both virgins and all my friends were doing it, so I finally decided it was time. It was that kind of thing. We were lucky because he was house-sitting for some relatives and that became our big chance to be alone. I went out and bought a

little bra-and-panties set and thought, finally, my night is going to happen. So we were at this house and kind of getting ready to proceed when some of his other relatives showed up to keep us company. We were half crazy at this point so as soon as we could we excused ourselves to take a little walk. We went down the road a bit and ended up next to a cemetery. We thought, who the hell will be in a cemetery? Let's do it in the cemetery. We climbed over this huge wrought-iron fence. I was so nervous, and I'm sure he was too. We sat down on a large, flat tombstone and we didn't do much of anything. Every moment was so awkward. We kissed and then he pulled down his zipper and put on a condom. I said, "You know what? Put on another." And he did. Then we sat there in this uncomfortable silence. I lay down and took off my clothes. Finally it happened. I went, "Ahh!" He said, "Are you OK?" He was so sweet. Then all of a sudden, we hear this, "Hey! What are you guys doing?" We look over and this guy with a flashlight is running toward us. We took off like mad and I tried to slip my shirt back on. I was thinking about so many things. Like my parents, like the dead people in the cemetery, like Jesus being able to see us in the dark. I swear. We got to the wrought-iron fence and he hopped over, but I got caught on the fence and my shirt ripped and I dropped my matching bra and panties. I was hanging from this fence completely exposed, yelling, "Help!" I got down but without my shirt and my underwear. So that's how I lost my virginity. I ran into him recently. I think he's gay. Actually, he's definitely gay and I'm just in denial. That's a whole other story.

ROSE

HE WAS FROM THE WRONG SIDE OF THE TRACKS.

I just thought he was the coolest thing on the face of the planet. His parents were Baptist Bible beaters.

My parents were livid. I hadn't done shit with a guy and I had all these feelings, but we didn't talk about

stuff like that when I was in high school. I mean, you didn't know what people did or were supposed to do or anything like that. And so the whole first year I guess all we really did was kiss and maybe he went up my shirt or something. I remember this one particular night I had been given a very strict curfew because we were going to get up the next day for Thanksgiving and drive to my aunt and uncle's house. We were in my green 1982 Cutlass Supreme and we drove to this overlook where couples parked. We were kissing and making out and stuff like that on the front seat of the car. It had bench seats, not bucket seats. We were lying on top of each other and we got all hot and heavy and my shirt came off and my bra came off. The next thing I knew he was taking my jeans off. The guy knew that I didn't want to have sex, but I couldn't figure out what the hell he thought he was doing. And then he took my underwear off, and he started going down on me. Well, I had no idea that people did this. You know, I had no idea. I remember being stiff as a board. I could not figure out what the hell was going on. I started crying. I said, "What are you doing?" He came up and he said, "I'm doing this." I said OK. So he did it again. I was so confused. Then, the thing is, I had this huge orgasm and I had no idea what I'd just had. And here I was in this parking lot with couples lined up on either side with the windows steamed and everything seeming so strange. Then we went home and he kissed me goodnight, and it was then that I noticed for the first time that he had a hard-on. It was weird because biological things were just starting to click in my head. I remember thinking that I never wanted the other cheerleaders to find out what we had done. **ALICE**

HE WAS MY FIRST LOVE.

I was seventeen and we had just started having sex. I thought I was going to marry him. One night we were driving around in his car and we ended up down on the boardwalk by the water, sitting on this bench. We started fooling around and then we started taking our clothes off. I was thinking, "I can't take my clothes off here." But the thing is, I was entranced with this guy. I would have had sex with him anywhere. So we take off all our clothes, except that I still had my cowboy boots on. This was probably only the sixth time I ever had sex in my entire life. I am sure people could see us as they walked by. All of a sudden he stood up and yelled, "The rubber isn't on me!" He started looking everywhere for it, though I'm not sure why he thought it could get very far away. All I knew was that he had more sexual experience than I had and I didn't know what was going on. Then he said, "I think it might be inside of you." So he tried to find it. We were on the boardwalk, and people were walking by, staring. I had my legs totally spread and he was on his knees trying to find it. We could not find it anywhere. We ended up going to the hospital. I was totally embarrassed. Of course the doctor found it in about one minute and we were out of there. I was mortified and I remember thinking as we drove home that I wasn't sure it was worth all the trouble. But then when we got to my house we did it again in the driveway. **VIVIAN**

I WAS WITH THIS GERMAN WOMAN

who eventually became my wife, but this was before that time. We hadn't been going out very long, and we had been to the beach together—I think it was Ocean City, Maryland. On our way back we were driving, and I remember that she had bought a very cheap, but nice, thin black dress. She was very beautiful, with long legs, and she had gotten a lot of sun. So as I was driving I reached over and put my hand up her dress. She didn't have any underwear on, and I played with her and we got extremely aroused driving down the interstate. I suggested we pull over and she agreed, but we couldn't find anyplace. Finally there was this truck stop area and I pulled the car in. There were a lot of trucks there, so we walked over a ways to where there was this detached trailer sitting without anybody around it. We crawled underneath it. It was a burning hot day, bright sunshine, and we were in this totally public area. We just crawled into the shade and fucked, hard and quick. Afterwards, we hopped in the car and got back on the interstate. **MORGAN**

I WAS IN HAWAII LAST FEBRUARY

and maybe my fifth night there I met this girl from Canada. She was out there on vacation too, I suppose. I met her at this hotel where I was staying about two blocks from the sea. It had a goldfish pond and an indoor-outdoor lounge area with couches and a bamboo garden, all for $15 a night. I was hanging out in the lounge and she came in with these two guys she was traveling with. I started talking to them and we ended up staying up very late. At some point everyone went upstairs to go to sleep, and we all said good night. For some reason I decided to hang out alone. A few minutes later, she comes back down looking at me really intensely. We hung out there for a while and then went up to the room I was in. The room was a normal hotel room that had been turned into a hostel with five sets of bunk beds. The balcony had been enclosed so that they could fit another bunk bed in the room, and that was where I slept. I had that bunk to myself, but the rest of the beds were filled up and everyone was sleeping. We went in and climbed on the top bed of my bunk. The whole time she was telling me that she was a good Catholic girl and that we couldn't have intercourse but everything else was OK. Right. Anyway, the first time, she screamed. The second time she screamed and clawed my back up. And then the third time she screamed and clawed my back up and fell off the bed. She was ferocious. Through it all she kept yelling out all these bizarre twisted fantasies that she had. There is no way anyone in the room slept through it all. Everyone definitely got their $15 worth. **IAN**

I WAS TWENTY-ONE AND HE WAS FORTY-FIVE.

He was one of the "big" people in town and everybody knew him. He was a disgusting guy, but he was a lot of fun. My friend and I would hook up with him, and he would take us out. We would go to some restaurant, and later he would do stuff to us. I usually didn't sleep with him like my friend would, but I would let him finger me. One time, there were these old businessmen sitting right at the next table and he was fingering both of us. I had this tiny little skirt on, and I don't think I was wearing any underwear. Anyway, he was fingering us and the old men were watching and I was loving it. Then I smelled his cologne. I knew the smell of it because it was the men's version of the cologne I wore. That made me really comfortable, and I started playing with him, which I hardly ever did. When I got up to go to the bathroom, he said he wanted to come with me. So we left my friend there in the booth with the old men staring at her, and we went to the bathroom together. I pushed him against the wall and pulled off his pants. He had on these running pants with elastic around the waist, so it was really easy. I sat on the sink, and we did it. He came really fast, but I didn't really know that at the time because it was the first time that I had really had sex. That was my first. When we got back to the table, my friend was sitting with the old businessmen having drinks. She wasn't serious though, she was just teasing them. **VICTORIA**

I HAD A CRUSH

on this very beautiful lawyer. But she had a boyfriend for the longest time, so we would just go have drinks

and then say good-bye, or go see a movie and then say good-bye. But there was always something there.

I was walking her home one night and she told me that she was breaking up with her boyfriend. Instead of the usual quick kiss we had a long, very sexy kiss, one of the sexiest kisses in my life. I guess about a month later she finally broke up with her boyfriend, and I offered to take her to a party. I picked her up in a cab, and the cab driver was not from America or any place close by. There were religious artifacts that I didn't recognize hanging everywhere in the car. Immediately after we started to drive, all the tension in our relationship finally broke loose and we started kissing. It was a hot summer night and I don't think he really had air conditioning because I remember we were a little bit sweaty from making out like that. All along the way we were kissing and I'm sure that the cab driver looked in this rearview mirror and saw us kissing, but he never said anything. We were kind of oblivious. I got a little crazier and lifted her skirt up and pulled down her underwear. I put my face between her legs and she kind of fell against the side of the cab moaning. For about thirty seconds it was heaven. Then the cab started jerking around and then it screeched to a stop. I figured we were just at a light so I kept going. The driver started yelling and I sat up, a bit dazed. The taxi was stopped on a side street and the driver was turned around with his eyes wide, glaring at us. He was shouting, "No, no, no, please don't do that. You may KISS but please don't do THAT." We sat up and stared out the windows. That was a very long, uncomfortable moment. Finally he turned around and drove. When we got to the party, he wouldn't touch my hand when I paid him. I think we violated some terrible taboo from his land. **LUKE**

I'VE ONLY BEEN TO YANKEE STADIUM ONCE.

I went up there with a couple of friends for the closing ceremonies of the Gay Games. On the way back, I got separated from my friends. There were so many people you could hardly walk around, and the subway was packed. I remember getting on the train, and it was such a strange experience because the car was filled shoulder to shoulder with gay men. There were a couple of people who weren't part of the scene and they didn't really get what was going on. I'm not sure what they thought, but it was an unusual scene, even to me. At one point I saw this guy on the train who was wearing tight Levi's jeans and no shirt. Amazing body, beautiful short-cropped dark hair, really cute, and looking at me. He kind of moved through the crowd and stood right next to me. Then he just started to touch me. We were packed in so close no one could really see that he had his hands down my pants. We both got really wound up. Then people started to notice. So we moved away to the back corner of the car, but it was still not private enough. We opened up the door and went between the cars as the train flew downtown. We started having sex, and the car was moving fast and rocking and jerking. I was thinking, "I can't believe I'm doing this." Then I looked up and there were people watching through the door windows of both cars. I was standing there having sex watching all of these people with their noses pressed up to the glass watching me. Then it became a performance in a way. It was very hot and it just went on and on and we both got off. It was a little crazy and scary. He was an animal. And I was really into it. **ROGER**

I MARRIED THIS GIRL

basically so she could get a green card. She's from Poland. She's really smart, and she speaks five languages. She's a skinny girl with green eyes and black hair and very white skin. A beautiful girl. She'd never had sex with anybody more than five times. She was fairly inexperienced in that way. We ended up getting married so she could stay in the country. We got married at City Hall and then drove my '82 Volvo station wagon home. We were married but we'd never had sex. It was weird but kind of sweet. We parked the Volvo on the top of a parking garage and it was great because you could see the Empire State Building. It was kind of late in the day, so the sunset was hitting the Empire State Building and it was all orange. You could see the flashes from the tourists' cameras on the observation deck. We ended up having sex there in the back of the station wagon with the seat down. I was behind her and we both could see the Empire State Building as all the flashes were going off. It was funny because we just went for a drive, and ended up getting married and having our honeymoon in the Volvo. We lay around there laughing for a while, smoked a cigarette, and then walked back to the apartment. We ended up driving each other crazy, but when we were there in the car I really thought it was going to last. **SAM**